When You Come to the Cottage, You Live a Different Way

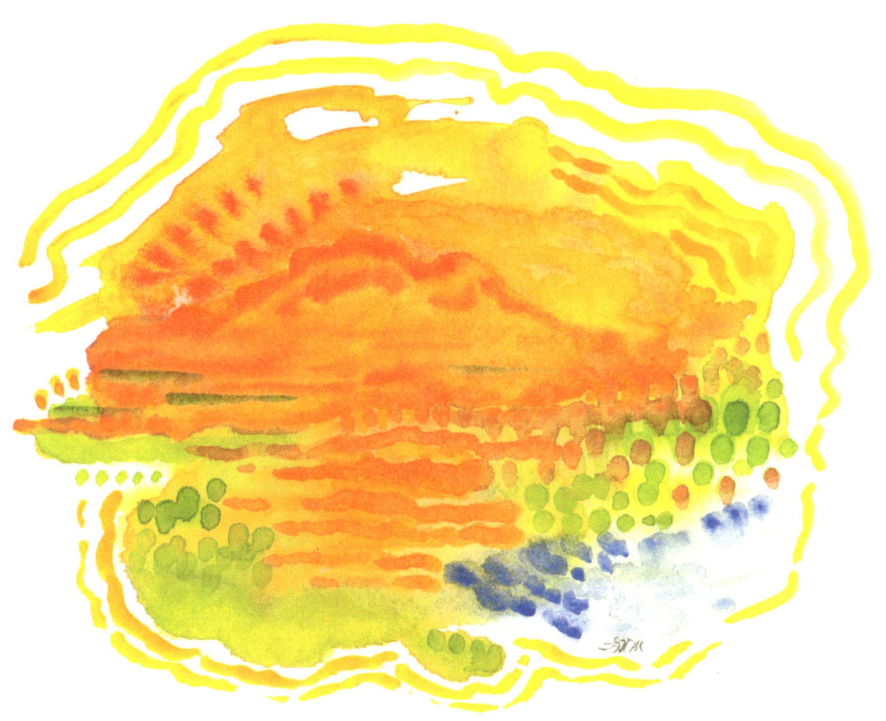

Story and Illustrations by
Sharon Mick McAuley

Artisans North
Frankfort, Michigan
2017

When You Come to the Cottage, You Live a Different Way
© 2017 Sharon Mick McAuley

All rights reserved. No part of this book, including text and illustrations, may be reproduced in any manner whatsoever without written permission except in the case of brief quotations embodied in program pamphlets, articles, and reviews. For information regarding use of the material, prints of the art work, and other art-spirit resources, address the author at Artisans North, PO Box 1120, Frankfort, MI 49635 or email *sharonmickmcauley@gmail.com*. Facebook: Riverain Song Studio @riverainsong

Book interior & cover design by Erin McAuley, *impluviumstudios.com*

ISBN: 978-1-387-01891-8

you come to the cottage,
ve a different way.

on't watch the clock,
se when you're rested,
hen you're hungry,
o what you've been wanting to do.

Gratefully de...
Grandpa Earl *and* Gra...

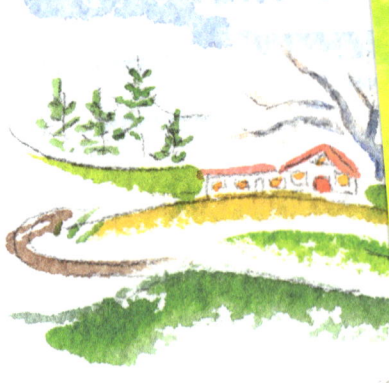

and their child...
Ethel, Mildred, Ren, Bi...

*Wher...
you l...*

You d...
you ri...
eat w...
and d...

You don't use electricity for everything, you cook over campfires or coals, hang laundry on a line, wash dishes by hand, and sweep with a broom.

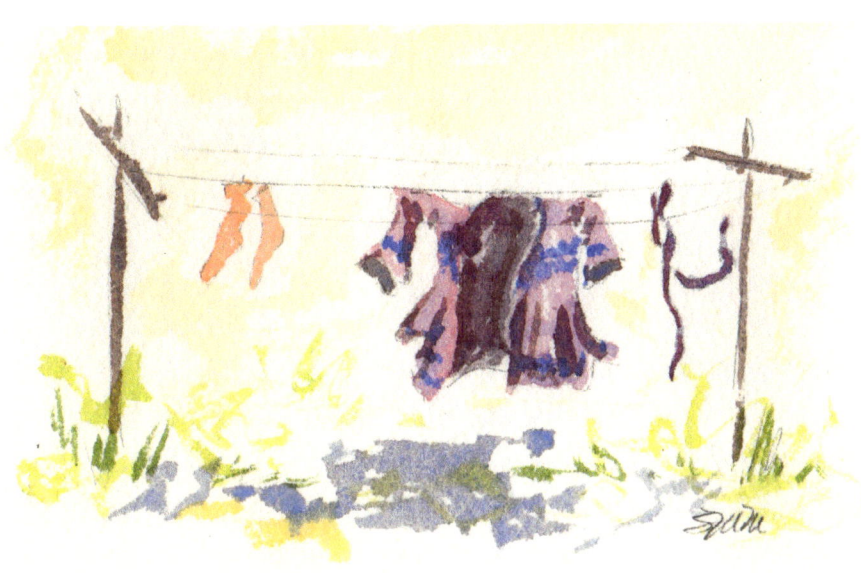

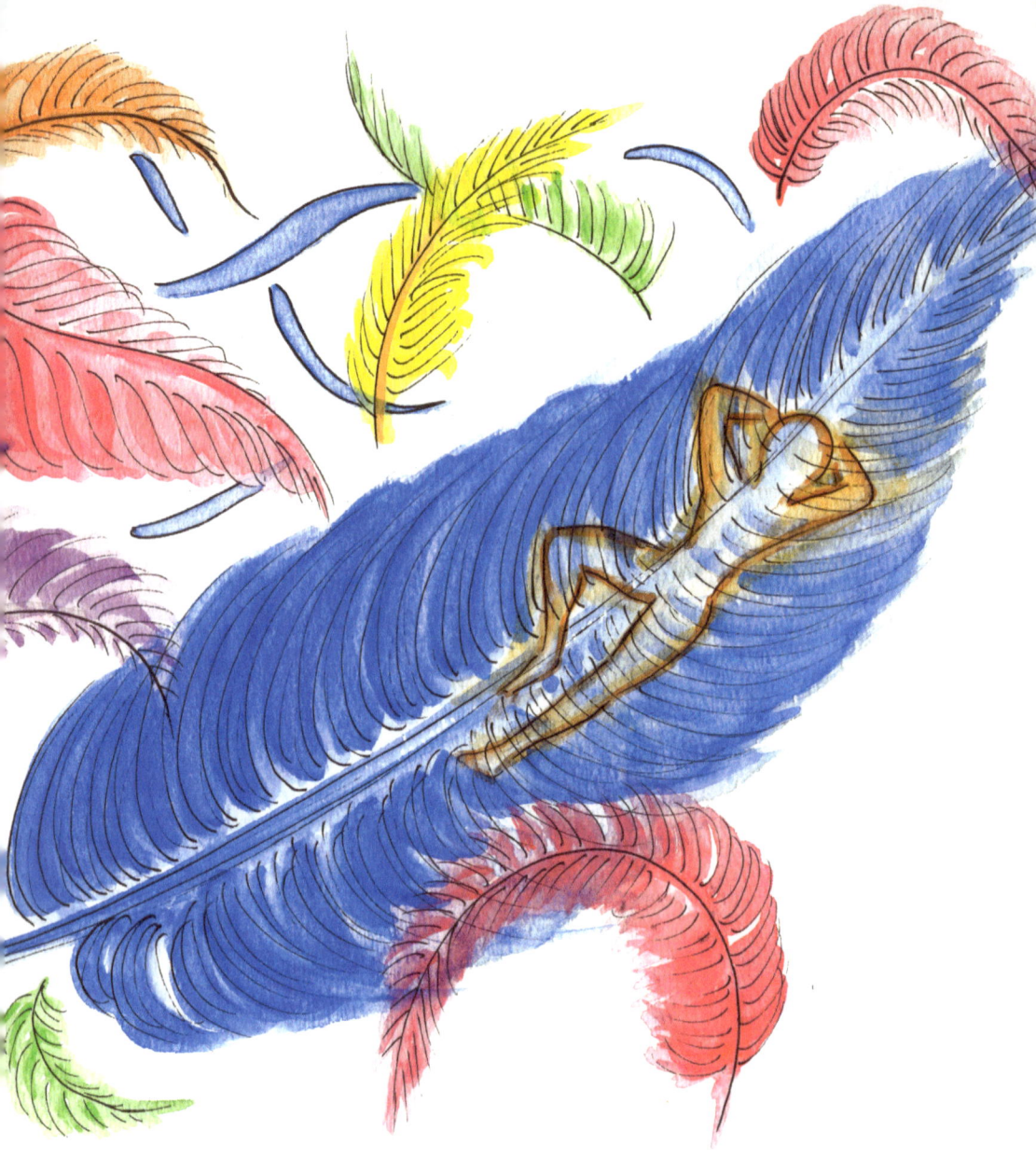

You don't worry about how you look,
you let the wind dry your hair,
use sunscreen instead of makeup,
and wear comfy clothes you don't have to keep clean.

You don't speed along busy highways,
you cruise down country roads, explore farms,
sample fresh-picked fruit, and feast your eyes
on the forests, fields, orchards, hills, and shorelines.

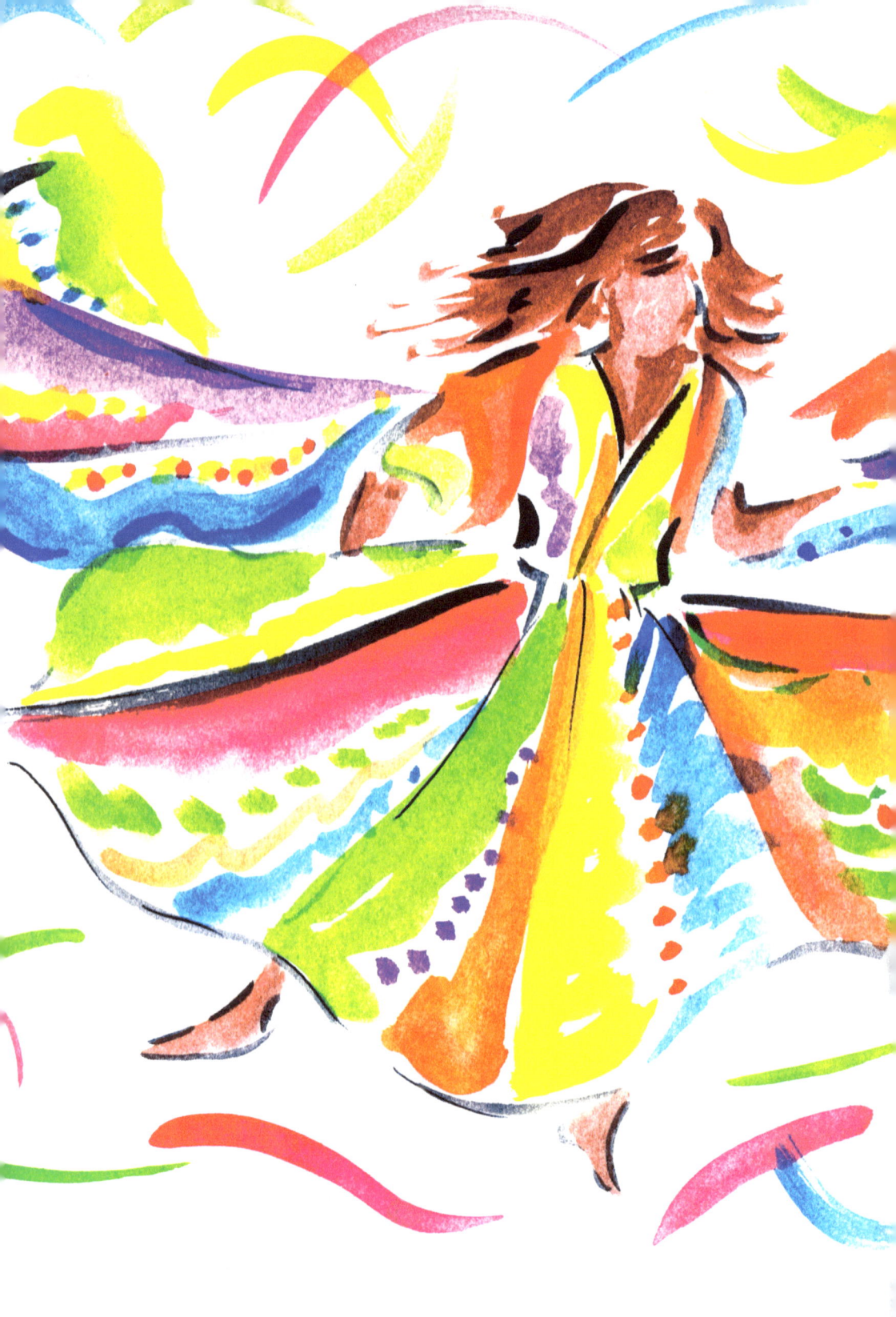

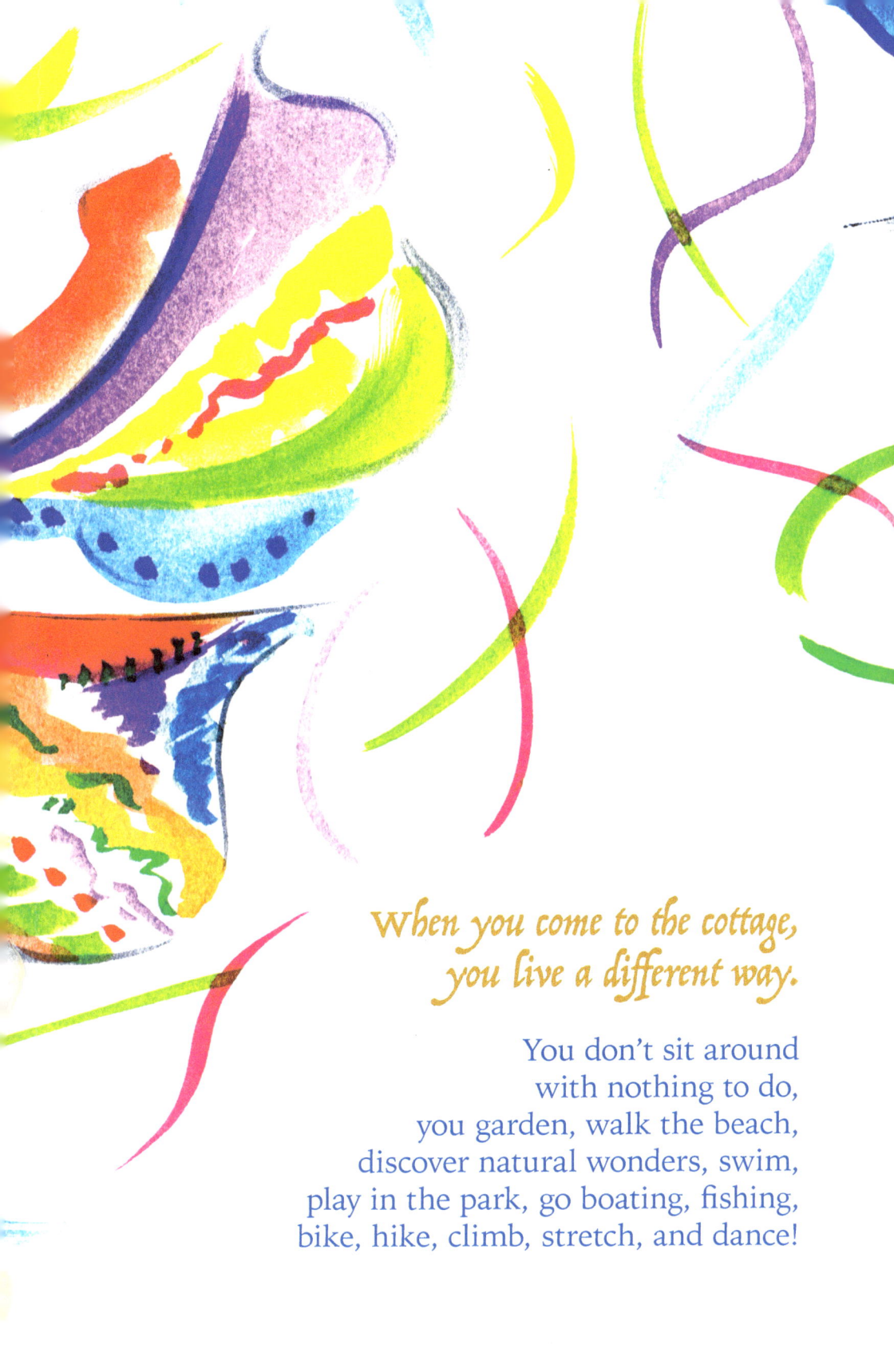

*When you come to the cottage,
you live a different way.*

You don't sit around
with nothing to do,
you garden, walk the beach,
discover natural wonders, swim,
play in the park, go boating, fishing,
bike, hike, climb, stretch, and dance!

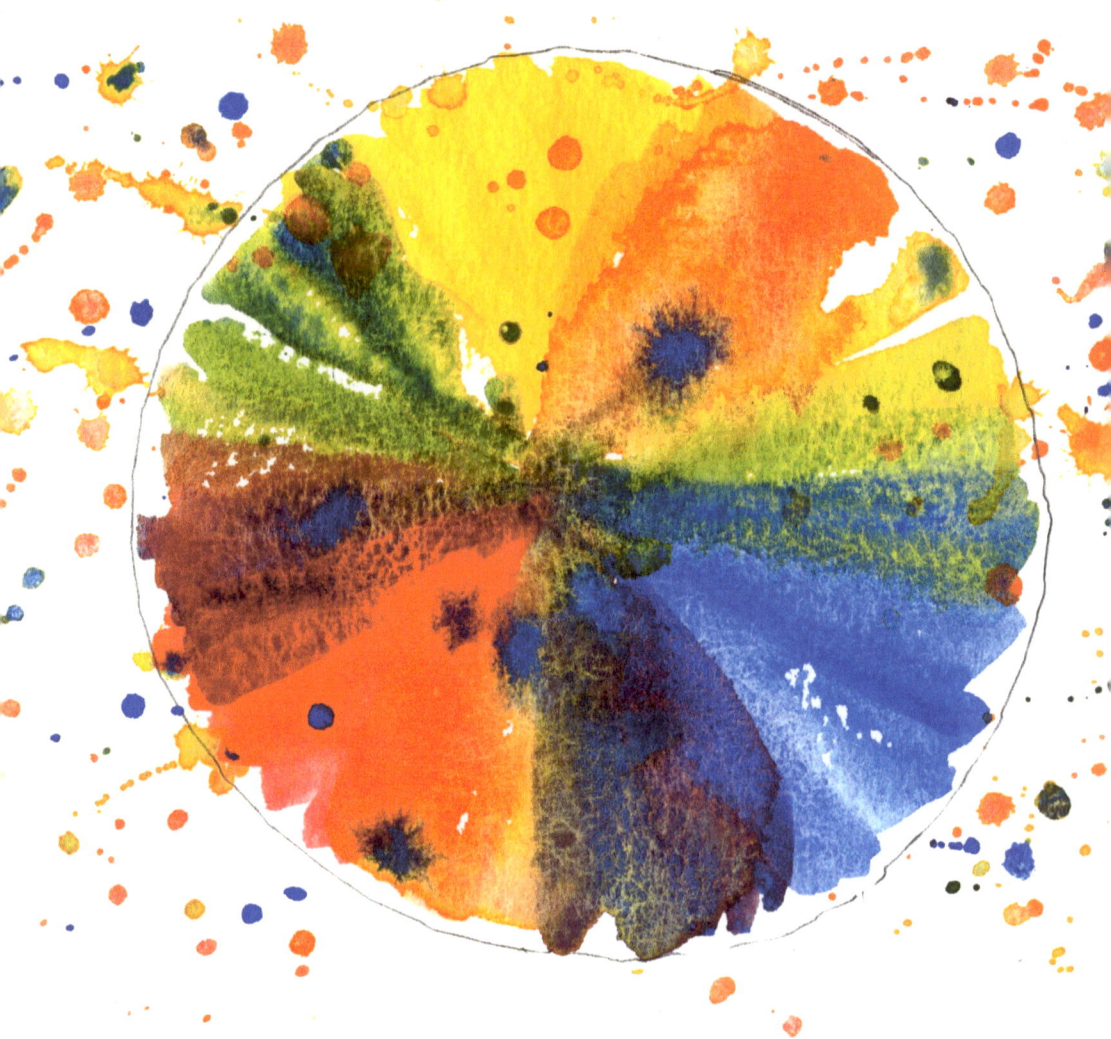

You don't need screens for entertainment, you read new and favorite books, talk to each other, play games, watch the sky, and let your creative imagination carry you away.

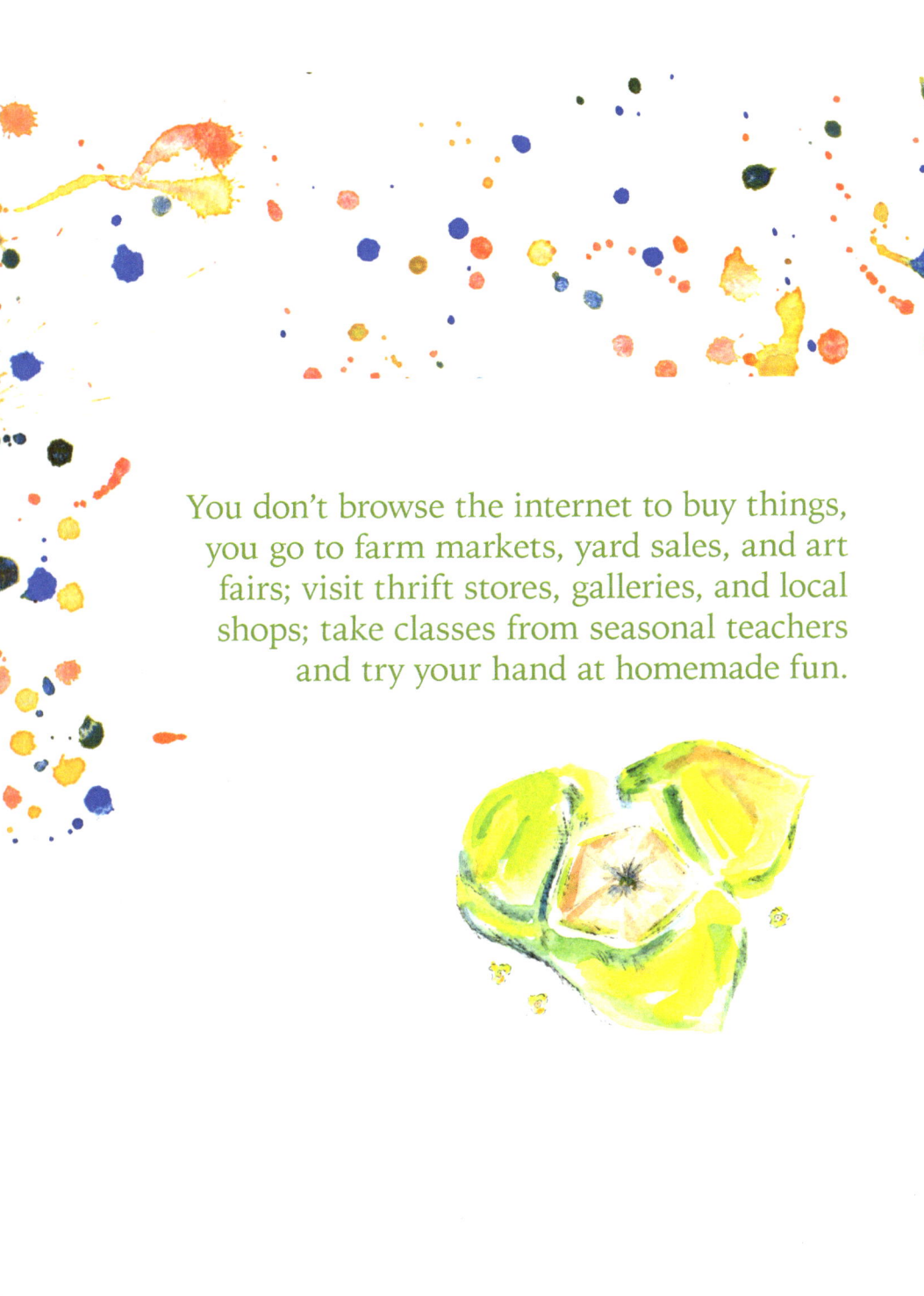

You don't browse the internet to buy things, you go to farm markets, yard sales, and art fairs; visit thrift stores, galleries, and local shops; take classes from seasonal teachers and try your hand at homemade fun.

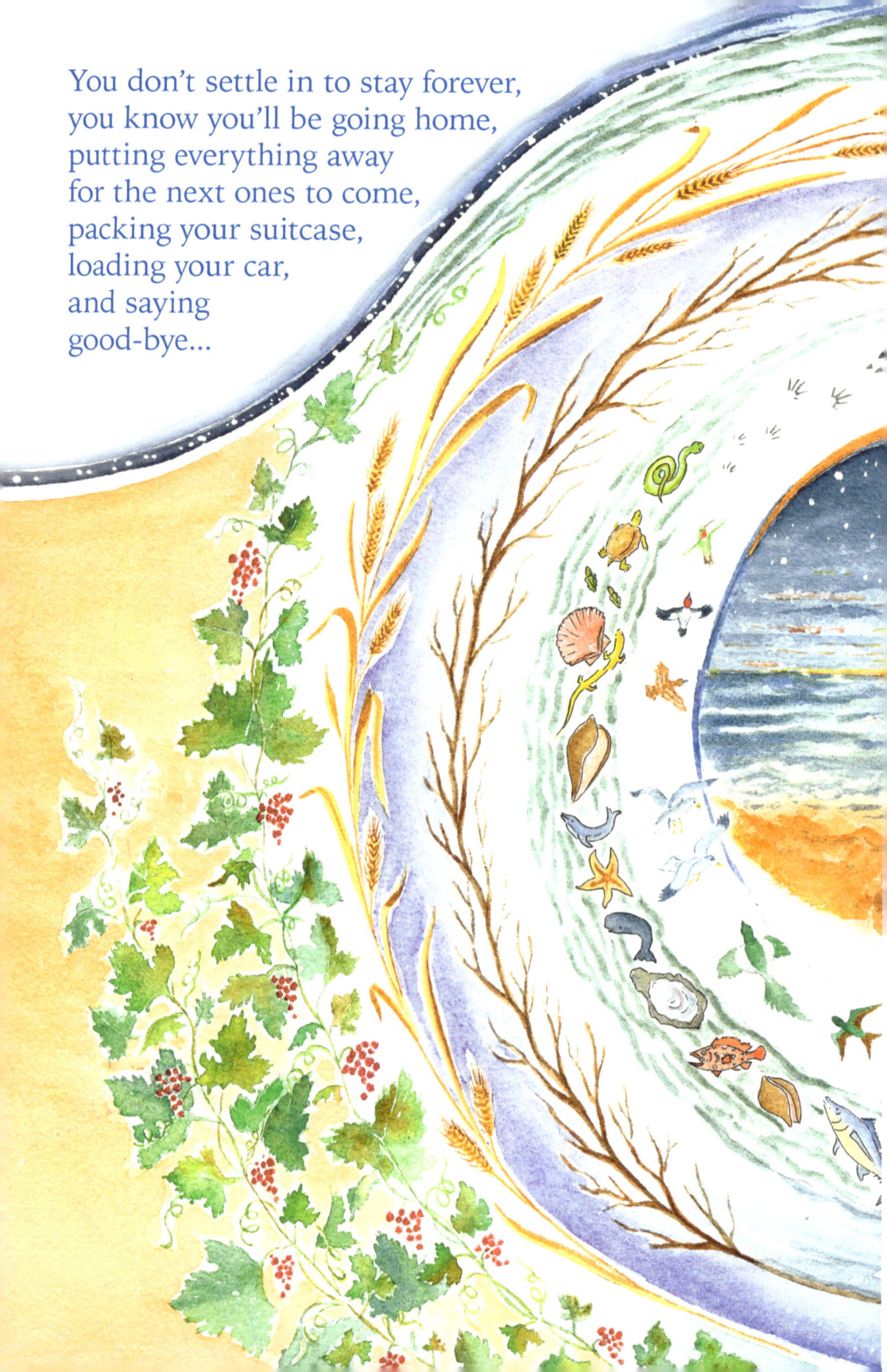

You don't settle in to stay forever,
you know you'll be going home,
putting everything away
for the next ones to come,
packing your suitcase,
loading your car,
and saying
good-bye...

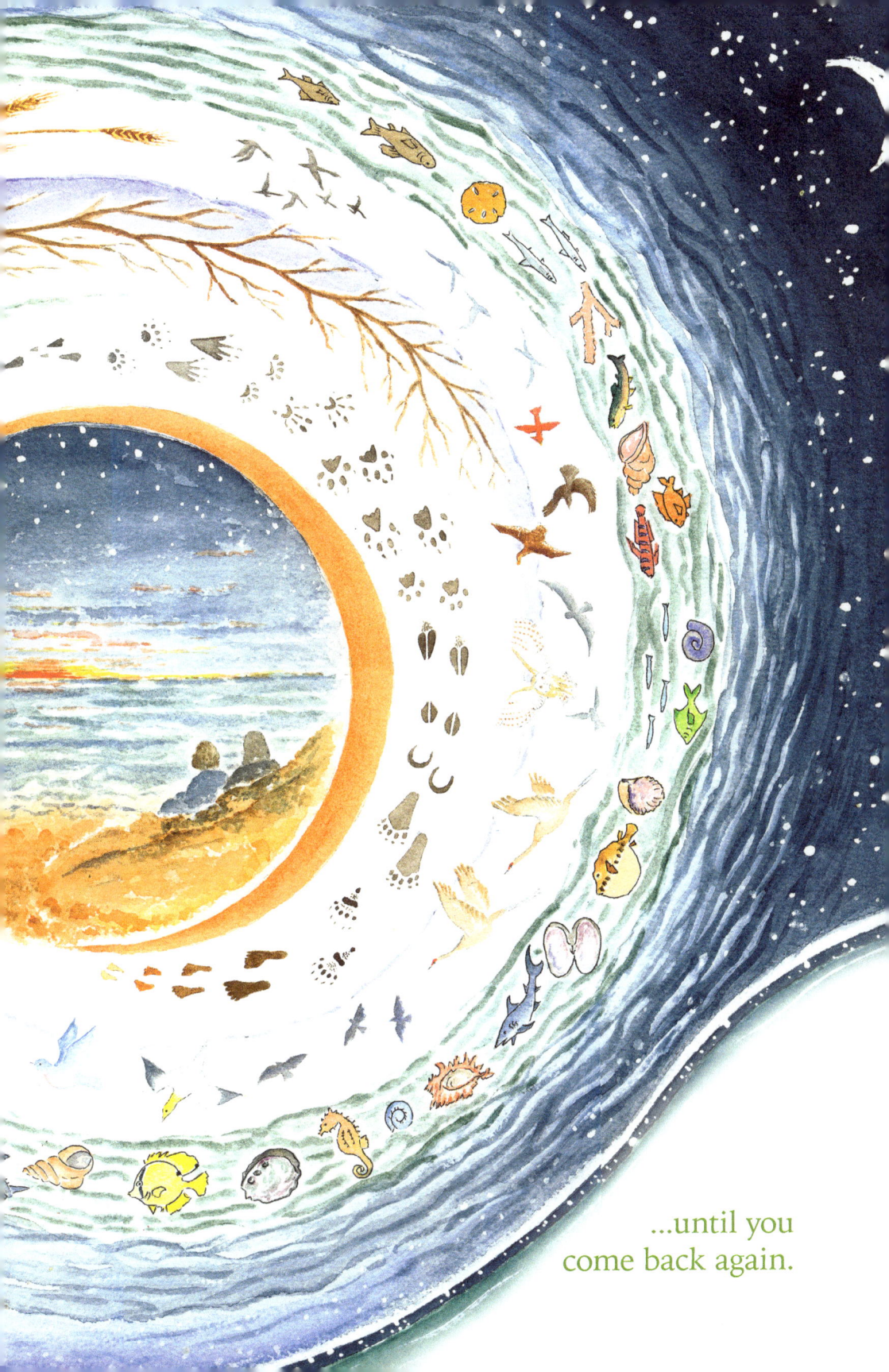

...until you come back again.

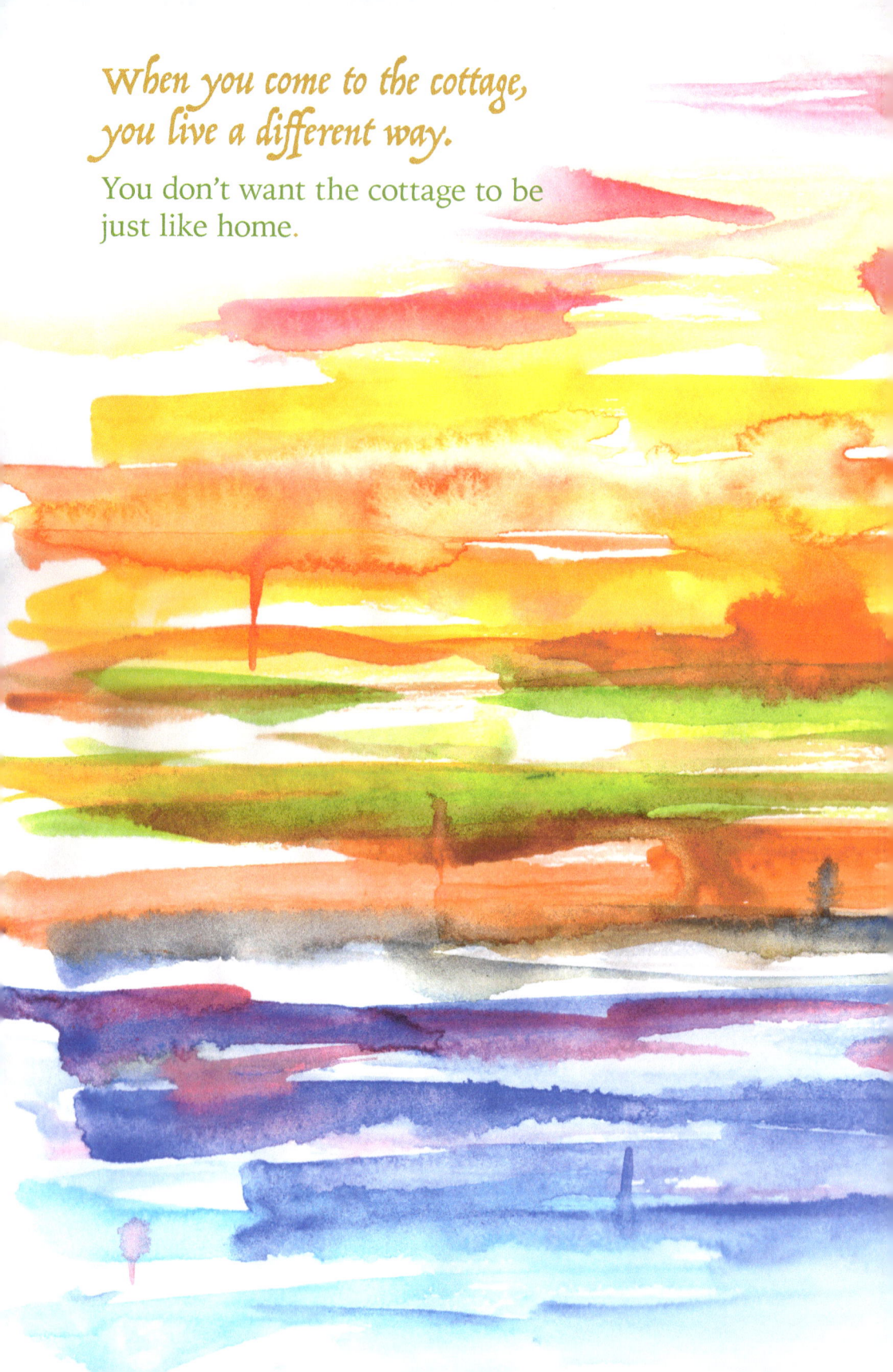

When you come to the cottage, you live a different way.

You don't want the cottage to be just like home.

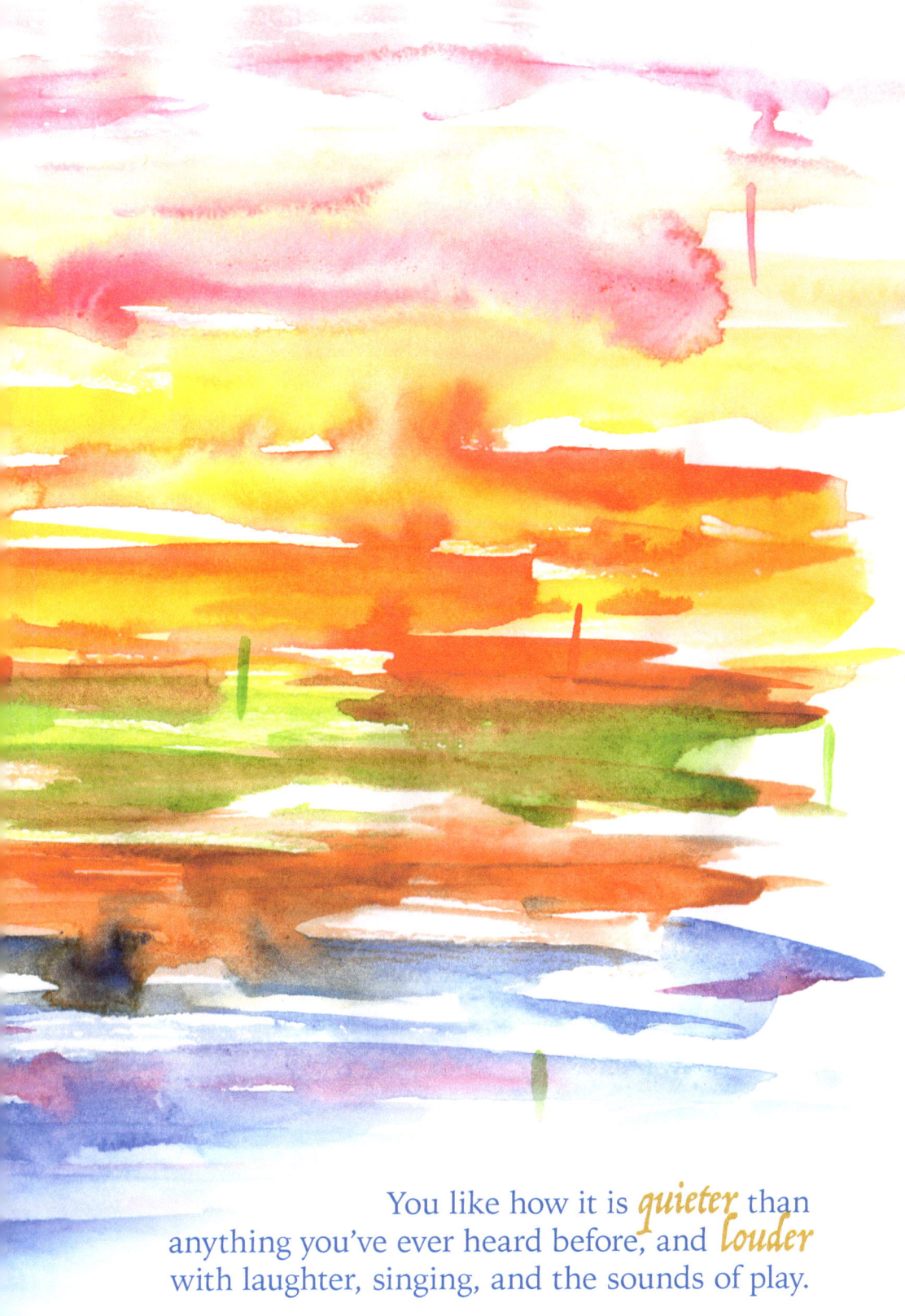

You like how it is *quieter* than anything you've ever heard before, and *louder* with laughter, singing, and the sounds of play.

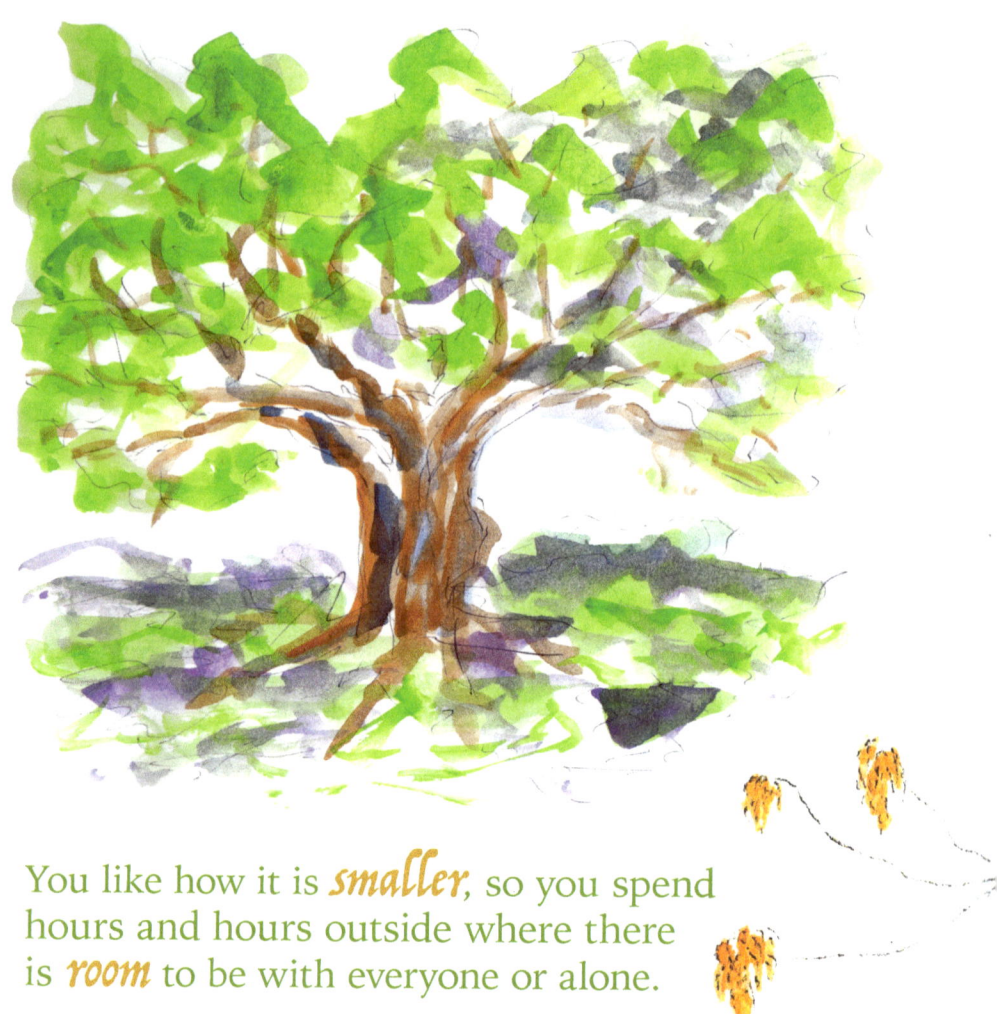

You like how it is *smaller*, so you spend hours and hours outside where there is *room* to be with everyone or alone.

You like how it is *emptier*, so meals and clothes
and activities are less complicated and less work,
and you find you have just *enough*.

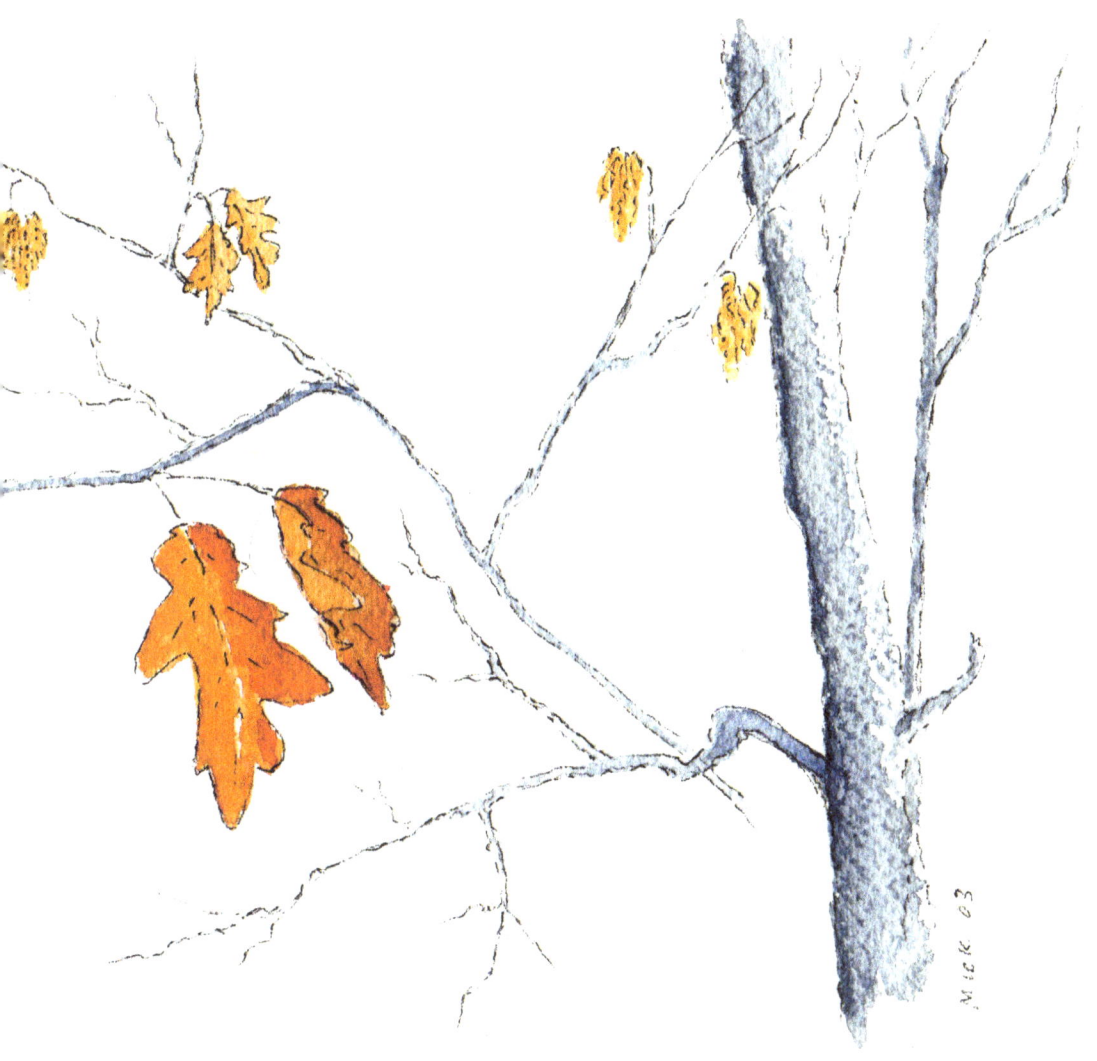

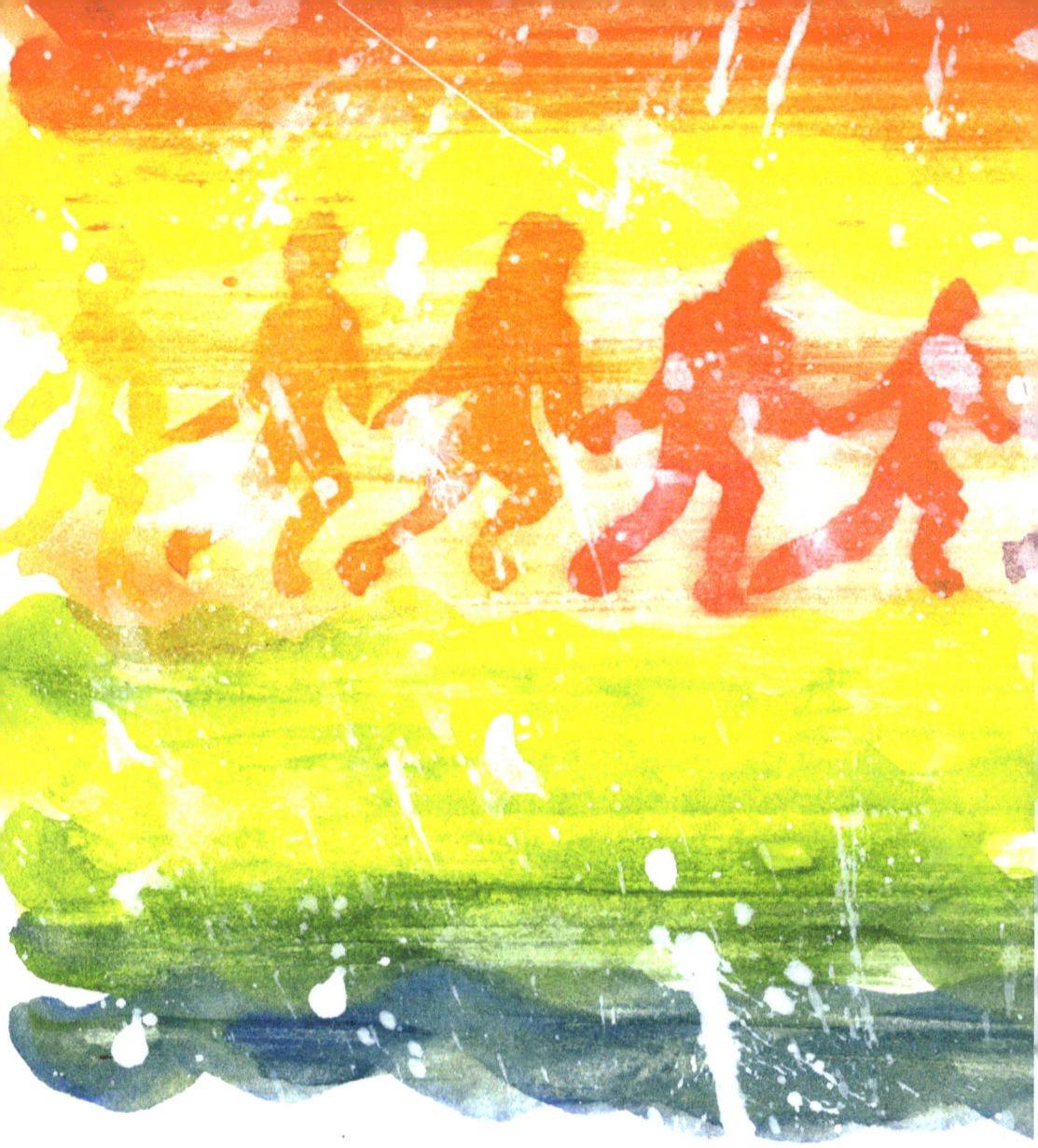

You like how it is *shared*,
so chores are done together, old memories are
relived while new memories are being made,
and dreams for its future belong to *everyone*.

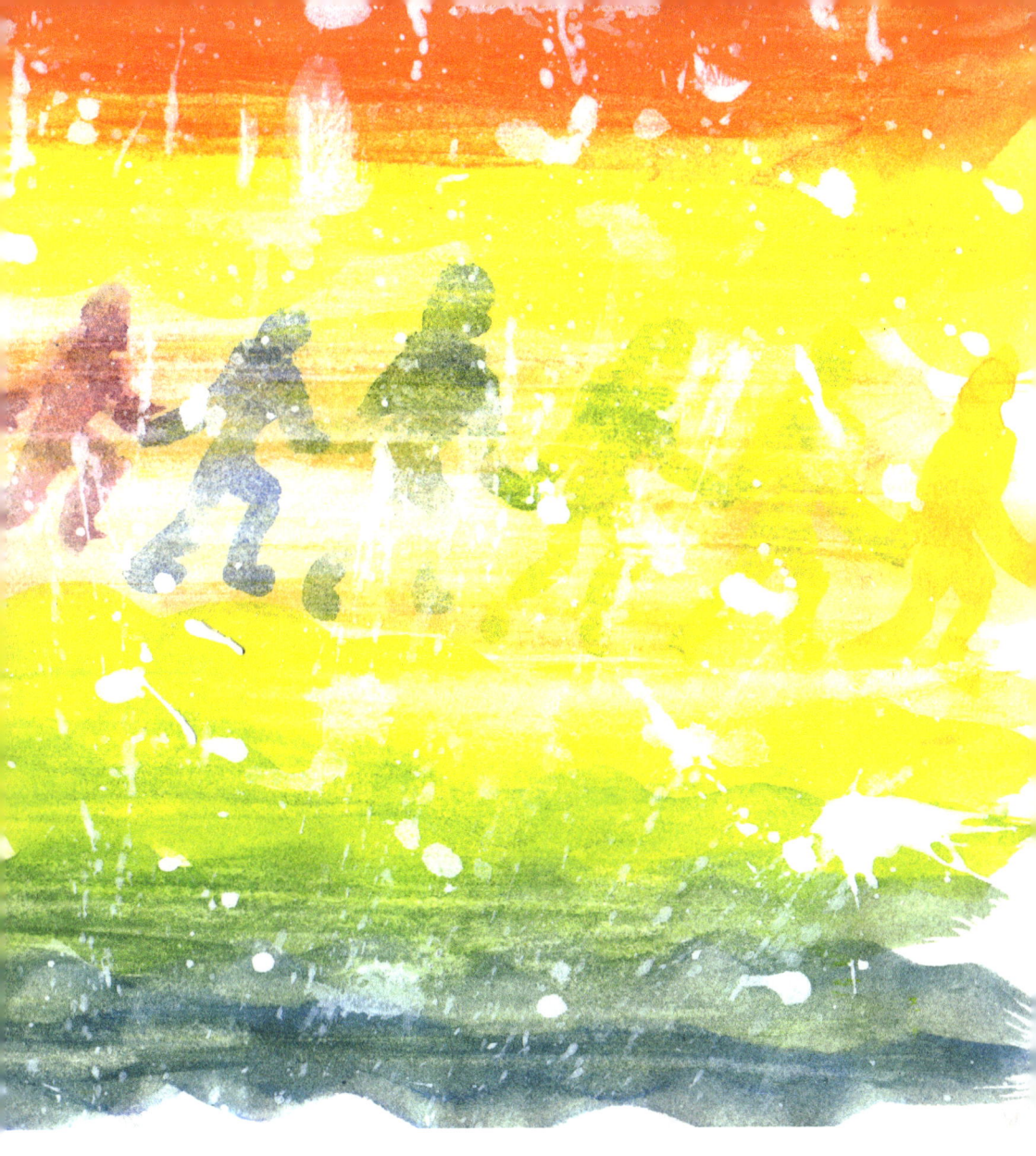

When you come to the cottage,
you are home in a different way.

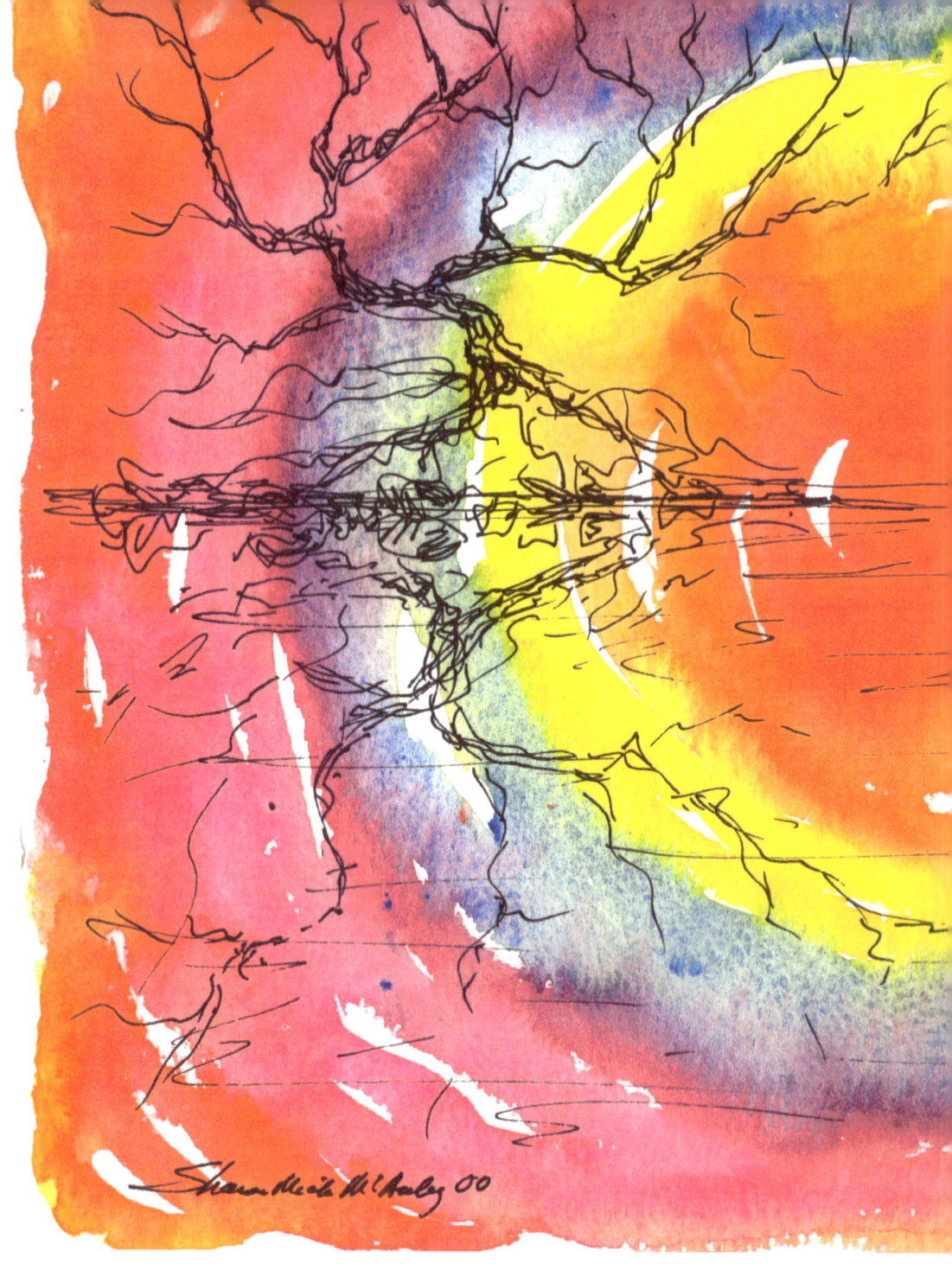

Not the end...

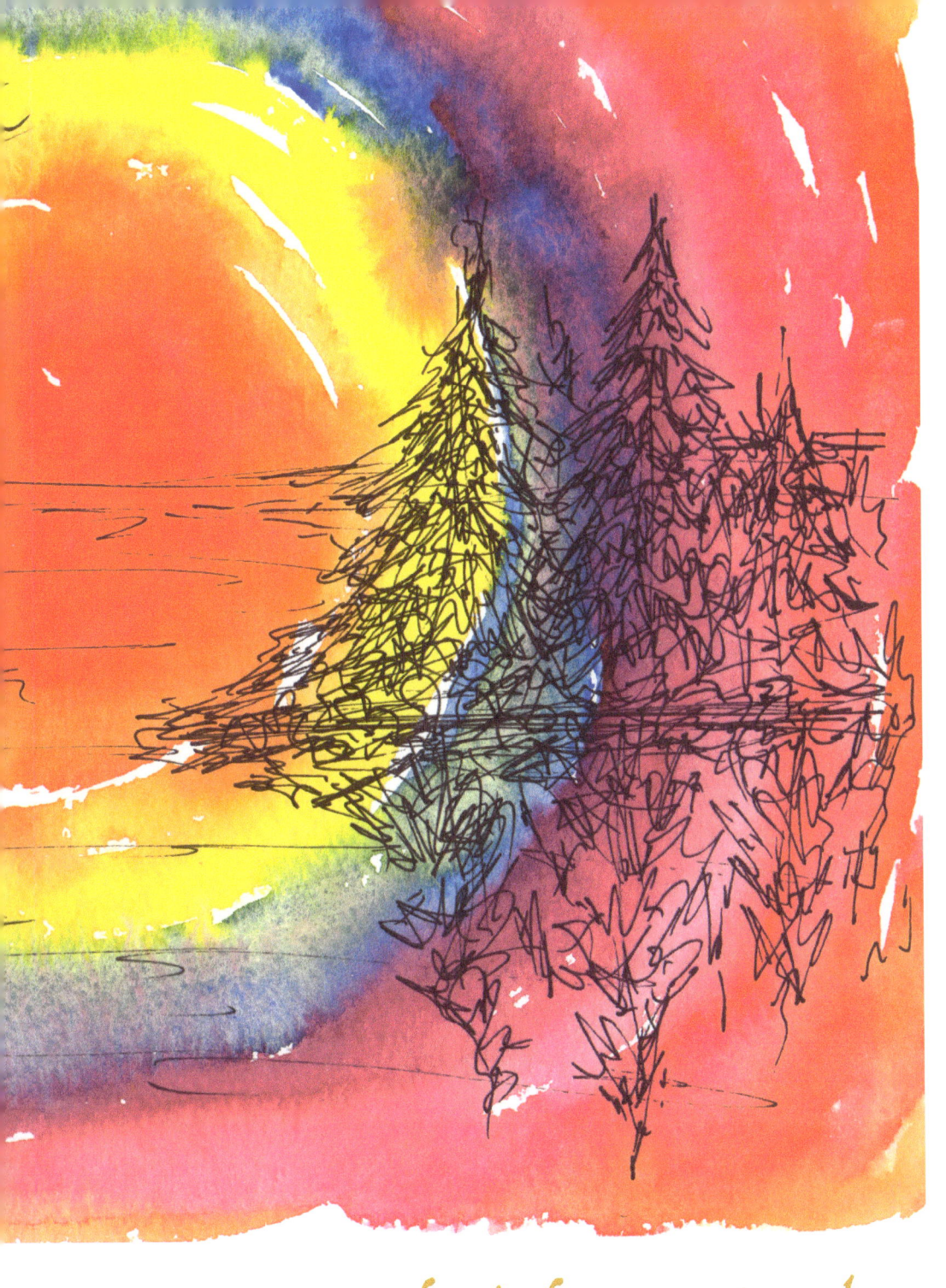

...There is always more to come!

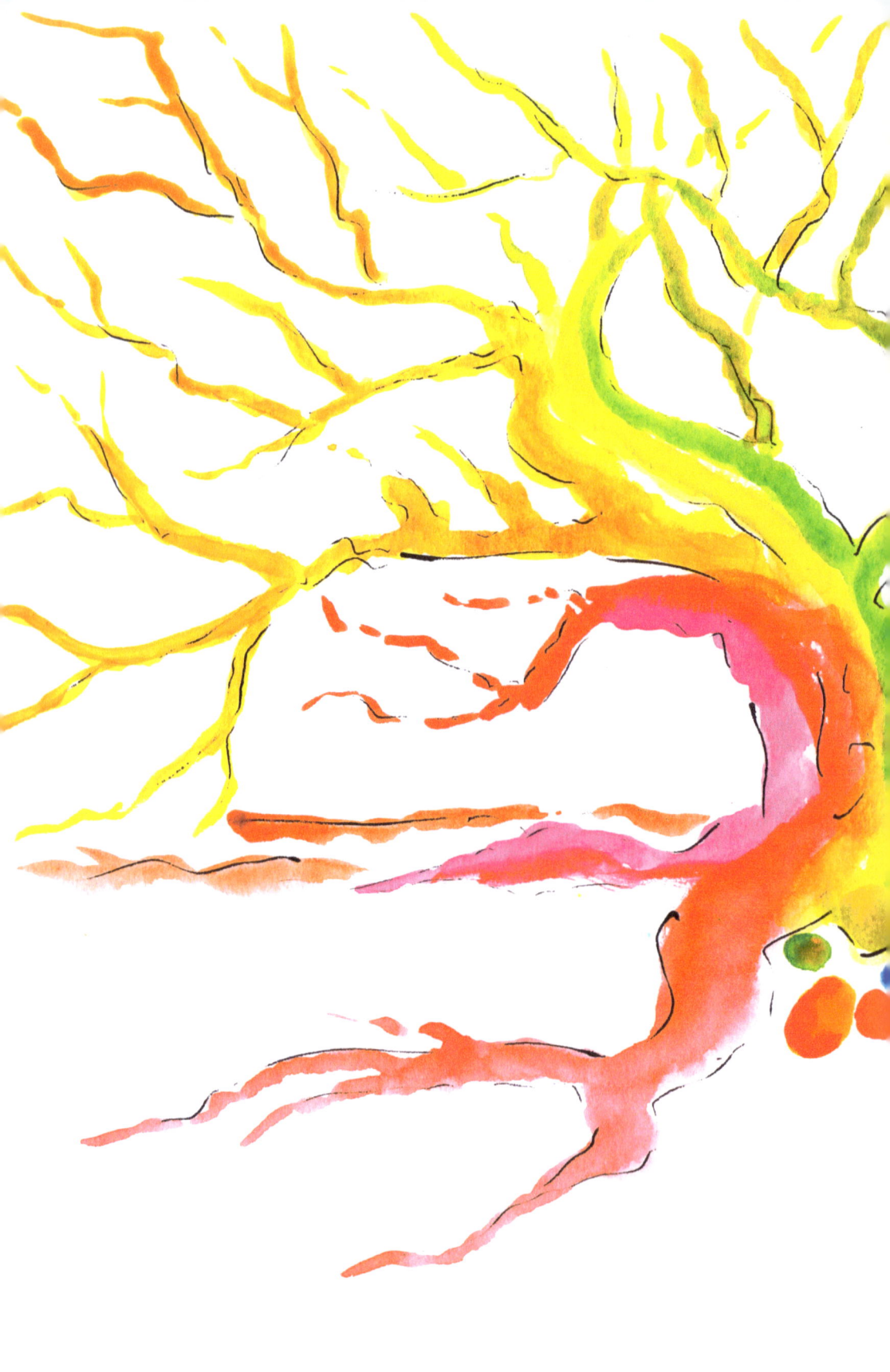

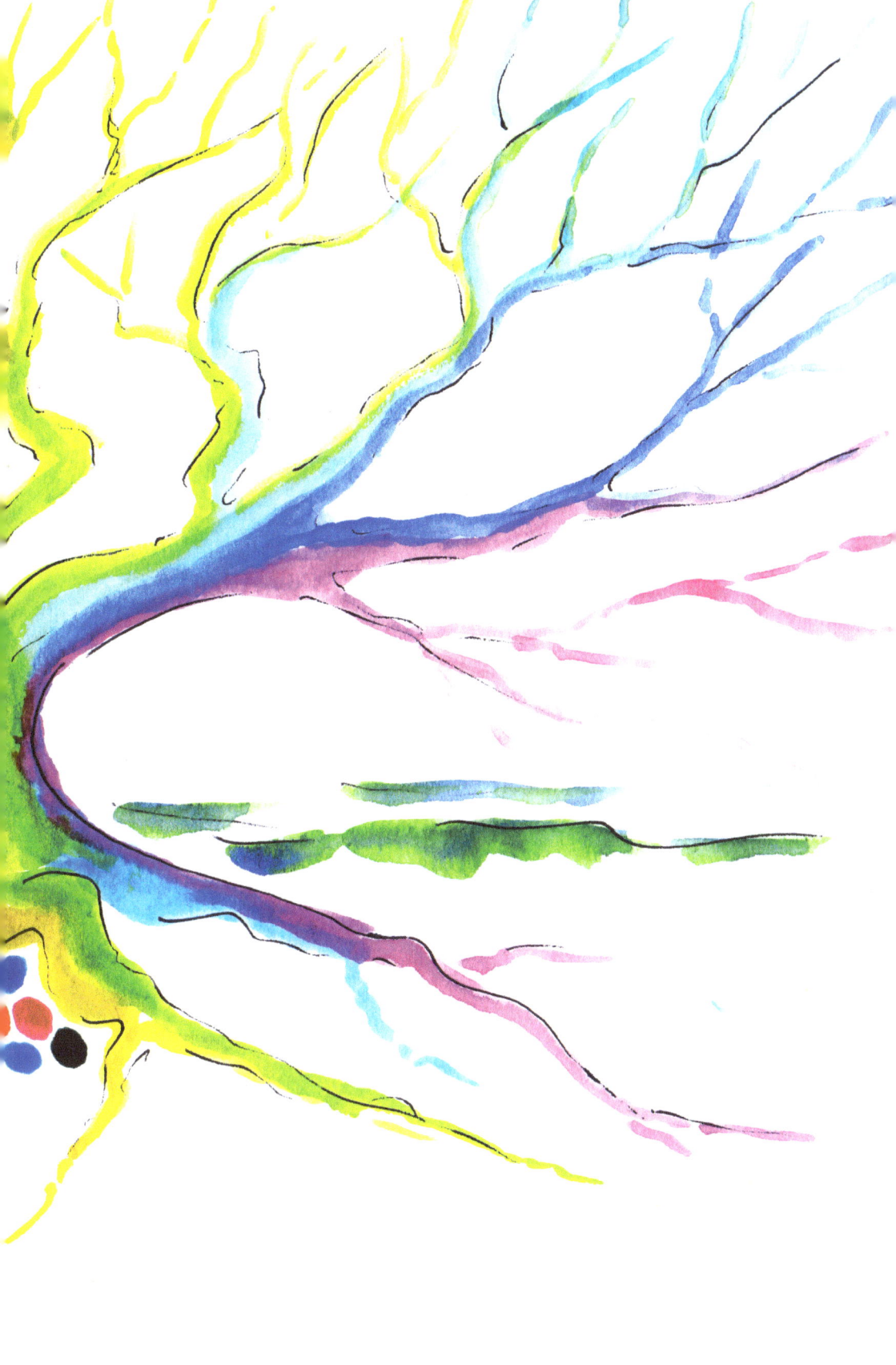

Illustrations by Sharon Mick McAuley

Sunrise

Like a Feather On the Breath

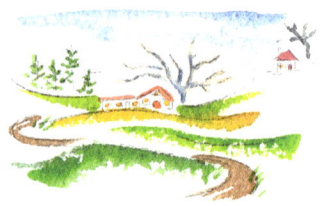
Old Farm

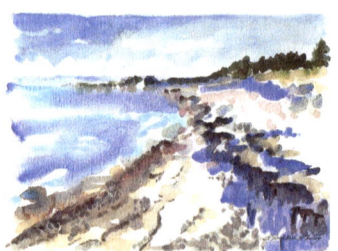
Spring Melt

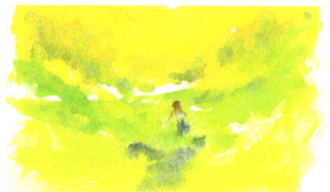
Walking in the Sun

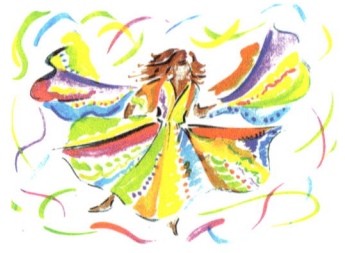
The Dance

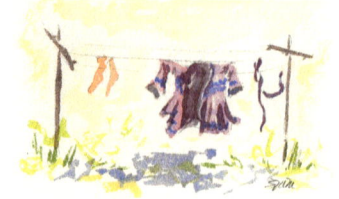
Sweater in the Wind

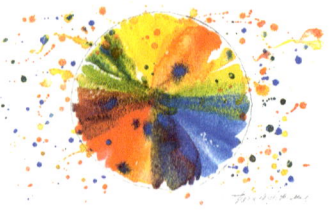
Color Wheel

Tiny Green Cap

The Last Leaves

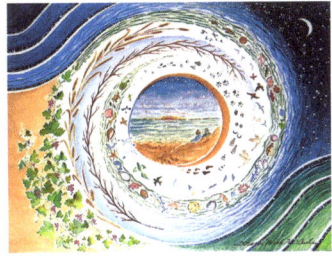

Creation

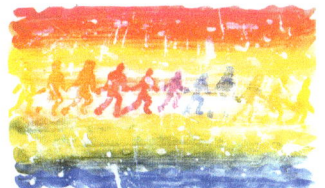

Together

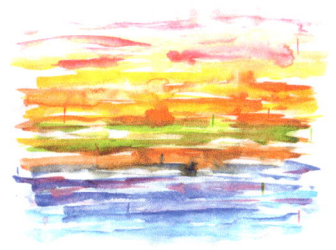

Borderlands

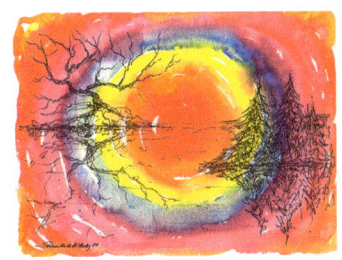

All the World Shines

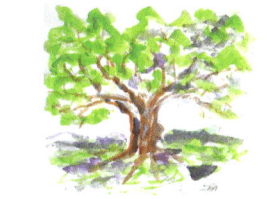

Sprawling Old Apple

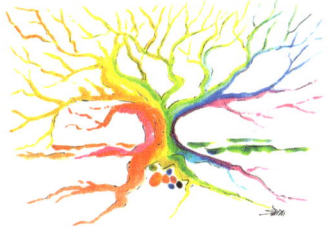

Prism Tree

Sharon Mick McAuley is an artist, songwriter, and spiritual guide who meets with individuals and leads ongoing art-spirit covenant groups. A native of Michigan, her art has been exhibited in Lansing, Grand Rapids, Flint, Frankfort and beyond.

Signature Pages for Shared Memories
Sign in, date, and write a few words.

www.ingramcontent.com/pod-product-compliance
Lightning Source LLC
Chambersburg PA
CBHW041116180526
45172CB00001B/276